MW00723778

H O L L Y W O O D

DOCTORS

E D I T E D B Y J . C . S U A R È S

T E X T B Y J . S P E N C E R B E C K

T H O M A S S O N · G R A N T

Published by Thomasson-Grant, Inc.

Copyright © 1994 J. C. Suarès.
Captions copyright © 1994 J. Spencer Beck.

Printed in Hong Kong.

ISBN 1-56566-068-4

00 99 98 97 96 95 94 5 4 3 2 1

Inquiries should be directed to:
Thomasson-Grant, Inc.
One Morton Drive, Suite 500
Charlottesville, VA 22903-6806
(804) 977-1780

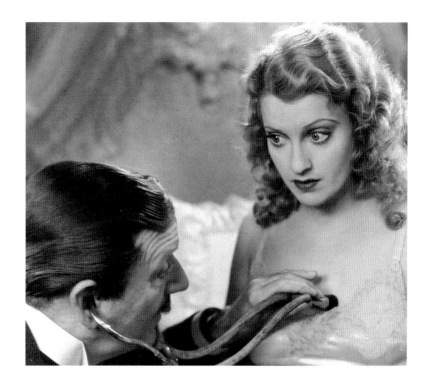

Joseph Cawthorn (with Jeanette MacDonald)
LOVE ME TONIGHT, 1932
A late-blooming character actor who made his film debut in 1927
at the age of fifty-nine, Cawthorn as Dr. Armand de Fontinac shares
a risqué moment with MacDonald's Princess Jeanette in this saucy
pre-Hays Code musical that introduced Myrna Loy's comic talents for
the first time. When someone is ill and asks, "Could you go for a
doctor?" Loy instantly replies, "Oh, yes, send him in."

They are the stars whose bedside manner has meant big box-office for over eighty years. In the movie capital, where melodrama means money in the bank, films featuring dedicated surgeons and general practitioners, kindly country doctors and big-city psychiatrists (and even the occasional medical man gone mad) have propelled some of our favorite leading men and women from studio extra to superstar overnight.

The movie moguls learned early on that romance mixed with a little medical mumbo jumbo often means magic on the big screen and long lines at the Bijou. When MGM cast a struggling actor and one-time pre-med student named Spangler Arlington Brugh in *Magnificent Obsession* in 1935, the newcomer's natural bedside manner (not to mention his bedroom *eyes*) made the rechristened Robert Taylor one of the biggest draws of the decade. And scores of Hollywood's handsomest leading men followed suit (George Brent and Clark Gable, Rock Hudson and Omar Sharif, to name a few)—mixing a bit of medicine with modern romance and making us all a little lovesick in the process.

Of course, Hollywood could get more serious, too. Warner Bros. specialized in the big-budget biopic, bringing the lives of real-life medical miracle workers such as Paul Ehrlich and Louis Pasteur out of the history books and onto the silver screen and garnering Oscar nominations for their headlining heroes (Edward G. Robinson and Paul Muni) in the process.

As in real life, Hollywood's men and women in white come in a

variety of sizes, shapes, and personalities. There are good doctors (Gary Cooper in *The Story of Dr. Wassell*, Lew Ayres in the Dr. Kildare serial) and bad (Charles Coburn in *King's Row*, Ronald Colman in *Arrowsmith*), doctors who treat the mentally ill (Montgomery Clift in *Suddenly, Last Summer*, Barbra Streisand in *The Prince of Tides*), and doctors who *are* mentally ill (Colin Clive in *Frankenstein*, Laurence Olivier in *Marathon Man*). There are even doctors who are a little of both (Spencer Tracy in *Dr. Jekyll and Mr. Hyde*, Richard Dreyfuss in *What About Bob?*).

Then there are the countless medical pros—played by some of Hollywood's most heralded character actors—whose names we may not recall, but whose faces are forever etched in the memories of moviegoers everywhere. Who can forget the kindly doctors who helped Tinseltown's most celebrated dying swans (Merle Oberon in *Wuthering Heights*, Bette Davis in *Dark Victory*) gasp their final breaths? And who saw Scarlett O'Hara through the death of her mother, best friend, and only child (not to mention half of the Confederate army), after all? (It was Hollywood old-timer Harry Davenport, of course.)

If the doctors we see on the big screen are perhaps a bit more heroic than the ones we deal with in real life, at least they give us hope and temporarily restore our faith in the Hippocratic oath. Ultimately, the celluloid images can't step off the silver screen and comfort us when we're sick. But it's nice to know that if they could, *they'd* surely make house calls.

Frank Sinatra

NOT AS A STRANGER, 1955

*Improbably cast as a medical student, the forty-year-old one-time
bobby-sox idol and future show-biz Chairman of the Board does his
best alongside fellow past-their-prime pre-meds Robert Mitchum and
Lee Marvin in this classic kitsch from director Stanley Kramer.
Long on raw emotion but decidedly short on bedside manner,
the superstar trio nevertheless had a minor hit with this soapy
adaptation of the best-seller by the same name.*

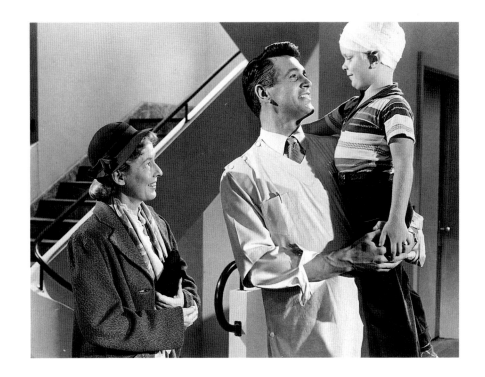

Rock Hudson (with Agnes Moorehead)

MAGNIFICENT OBSESSION, 1954

*Thoroughly green when he arrived in Hollywood in the
late 1940s (the first line he ever uttered on film required thirty-eight
takes), the pretty-boy bit player born Roy Scherer, Jr. finally proved
he could carry a picture in this movie that catapulted him to stardom.
The same part that had made Robert Taylor an overnight
sensation twenty years earlier, Hudson's role as the womanizing
wastrel-turned-Dr. Dogood may have been hard to swallow,
but for the first time, the star's acting wasn't.*

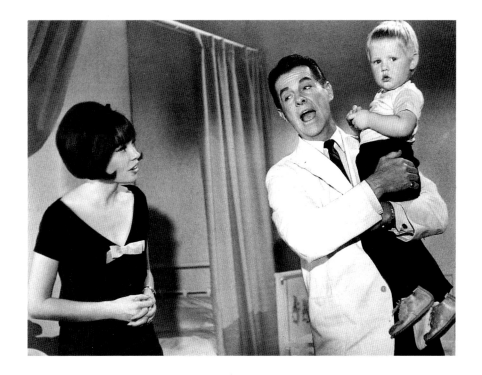

Robert Cummings (with Leslie Caron)

PROMISE HER ANYTHING, 1966

*Having played a serious medical student more than
twenty years earlier in* King's Row, *Cummings graduated to
full-fledged doctor in this cutesy romantic farce directed by Arthur
"Love Story" Hiller and starring tabloid lovers Warren Beatty and
Caron. A self-professed health-food freak and vitamin junkie,
the remarkably youthful fifty-eight-year-old actor offered
medical advice off the set as well: his best-selling* How to Stay
Young and Vital *sold over a million copies worldwide.*

Will Rogers

Dr. Bull, 1933

The down-home actor whose radio and newspaper pronouncements helped put Franklin Roosevelt in office was the number-two box-office draw in 1933 (behind costar Marie Dressler). His portrait of a genial country doctor who triumphs over his own lack of medical training in this John Ford-directed classic was a perfect vehicle for the former rope-twirling vaudevillian, who spent well over a decade in mostly obscure films learning his acting craft on the job.

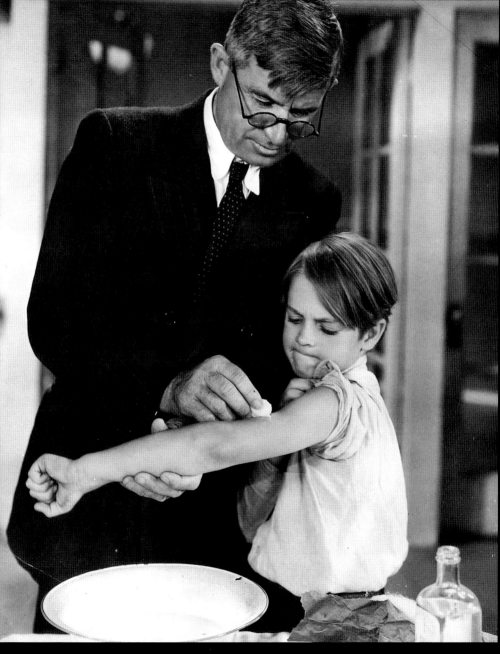

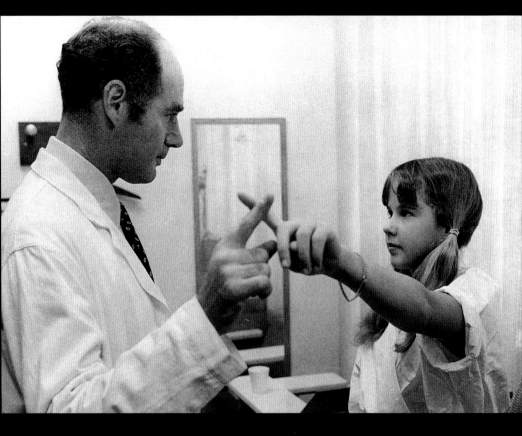

Burton Heyman (with Linda Blair)

THE EXORCIST, 1973

No mere doctor can cure she-devil Blair,
whose fits of vomiting, incontinence, and all-around ill temper
baffle her stage-actress mother and the virtual army of medical
professionals called in to save the child. Preying as much on everyone's
fear of helplessness in the face of terminal illness as on Satan per se,
the controversial film includes some of the most harrowing
hospital scenes ever committed to celluloid.

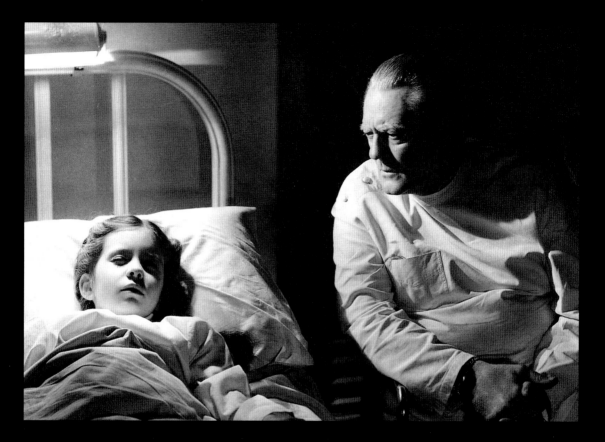

Lionel Barrymore (with Margaret O'Brien)
DR. GILLESPIE'S CRIMINAL CASE, 1943
*The gruff older mentor of young Dr. Kildare (played first by Joel McCrea
and then by Lew Ayres) in the first ten installments of the long-running Kildare-
Gillespie serial, Barrymore went on to star alone in five more of the popular
MGM hospital dramas after the studio dropped Ayres, who had declared himself
a conscientious objector and refused military service during WWII. Even confined
to a wheelchair, the veteran character actor and older brother of John Barrymore
managed to run busy Blair Hospital—as well as solve the occasional
murder mystery—in this forerunner of the 1960s television series.*

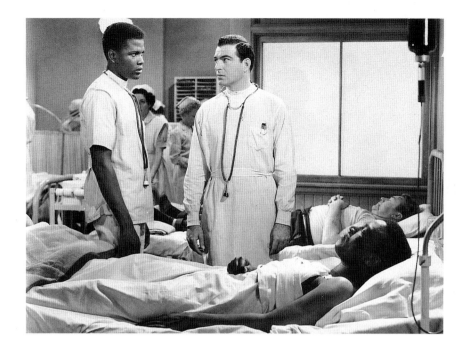

Sidney Poitier and Stephen McNally
No Way Out, 1950 (ABOVE)

*The first major black star whose popularity crossed racial boundaries,
Poitier played a number of professional men in movies throughout
the 1950s and 1960s. In his first film and one of the few studio-
financed anti-racist efforts that still hold up today, the son of poor
Bahamian tomato growers gave a tour-de-force performance as a young
doctor battling for lives—and respect—in a big-city hospital.*

Aline MacMahon and Ben Gazzara
The Young Doctors, 1961 (RIGHT)

*Soulful veteran actress MacMahon and rebellious newcomer
Gazzara were perfect foils for one another in this better-than-most
Dr. Kildare-like hospital soaper. When old Dr. Pearson
(Fredric March) lets his resentment of his young assistant stand
in the way of professionalism, tragedy naturally ensues.*

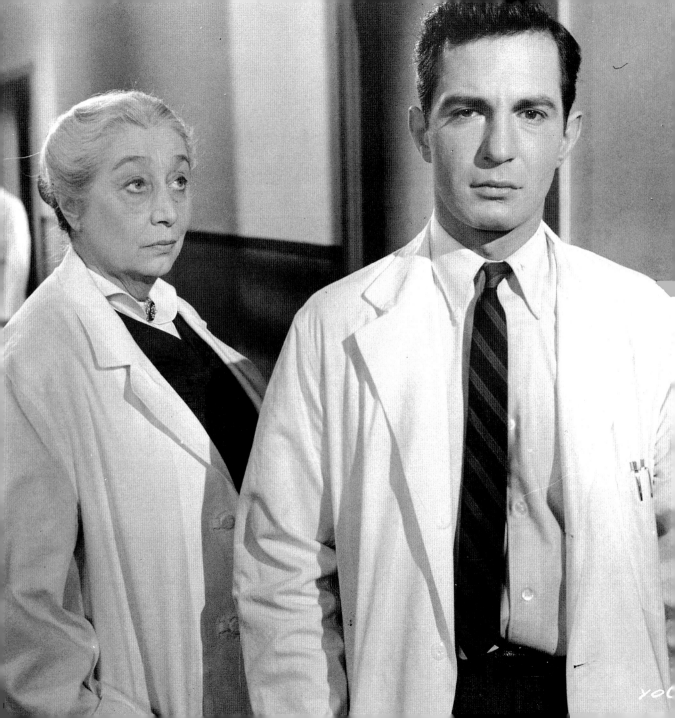

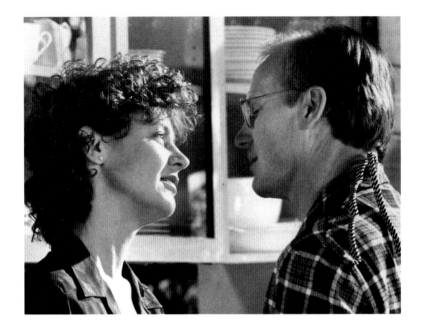

William Hurt (with Christine Lahti)
THE DOCTOR, 1991 (ABOVE)

*When a repressed surgeon (Hurt) becomes a cancer patient himself,
he gets a taste of his own bitter medicine in this uncompromisingly
realistic look at the dehumanizing effects of big-city hospitals.
One of the few Hollywood dramas to take on the sacrosanct medical
profession, the film points up that doctors are mortals too.*

Joel McCrea (with Barbara Stanwyck)
INTERNES CAN'T TAKE MONEY, 1937 (RIGHT)

*Promoted by Paramount with the line "He risked his life to save
a rat . . . and what did he get for it?", this first installment in the
long-running Dr. Kildare serial featured more gangsters with guns
than doctors with needles. Later recast and restyled by MGM, the
melodramatic series went on (with McCrea replaced by Lew Ayres)
to become one of the most successful in the history of Hollywood.*

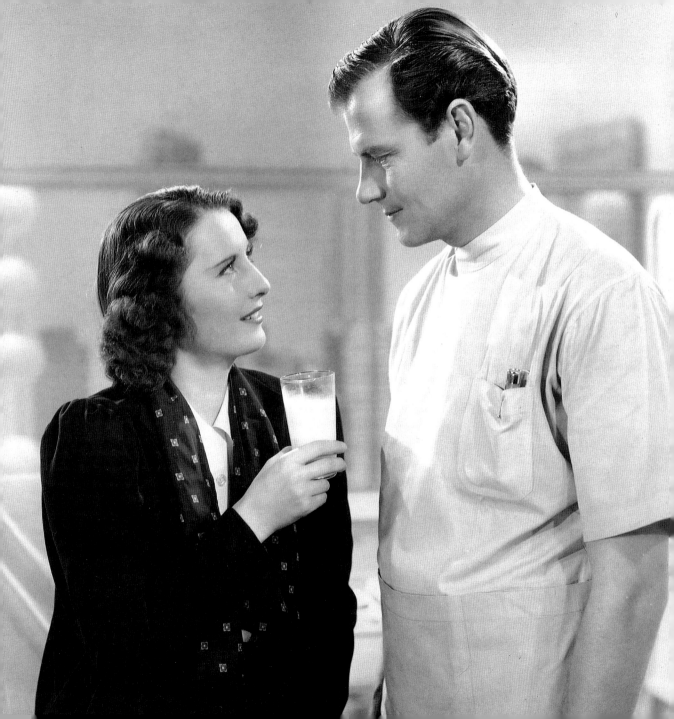

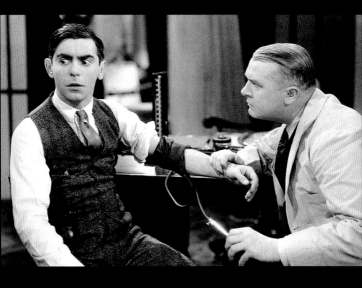

Eddie Cantor
INSURANCE, 1920S (ABOVE)

*The high-strung vaudeville star and sometime film actor
born Edward Israel Izkowitz was particularly pop-eyed having his
blood pressure taken by a concerned doctor-cum-insurance agent in
this rare comedy short. Although his large, expressive eyes were tailor-
made for silent film, Cantor wouldn't achieve real movie stardom
until the advent of sound in the 1930s allowed him to
showcase his considerable musical talents.*

Moroni Olsen (with Joan Crawford)
POSSESSED, 1947 (RIGHT)

*Films about the previously taboo subject of mental illness came
to the fore during and after WWII, when the collective nightmare of
total war and the ensuing social upheaval left so many people needing
reassurance. Audiences seemed to enjoy the celluloid shock therapy of
noir classics such as* Gaslight, Spellbound, The Dark Mirror, *and*
The Snake Pit, *as well as this Oscar-nominated Crawford vehicle,
in which no fewer than three psychiatrists were needed to deal
with the protagonist's melodramatic schizophrenia.*

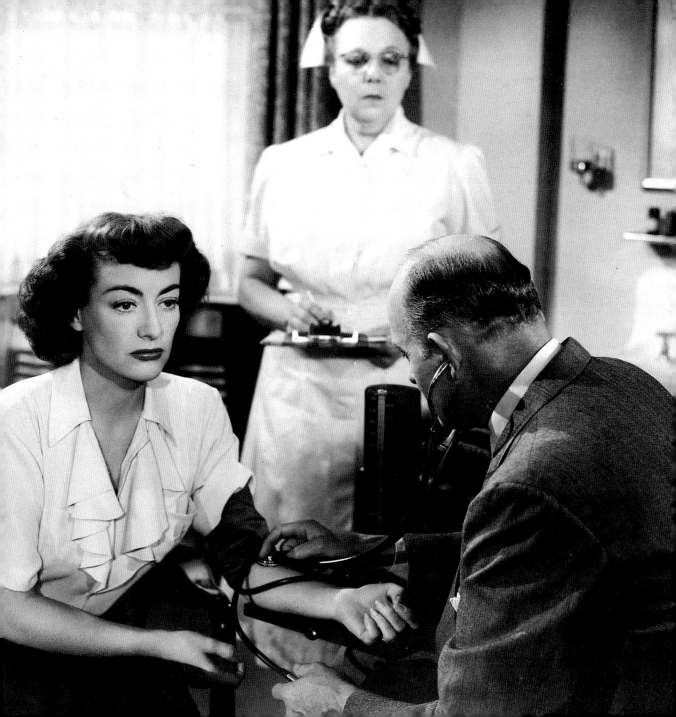

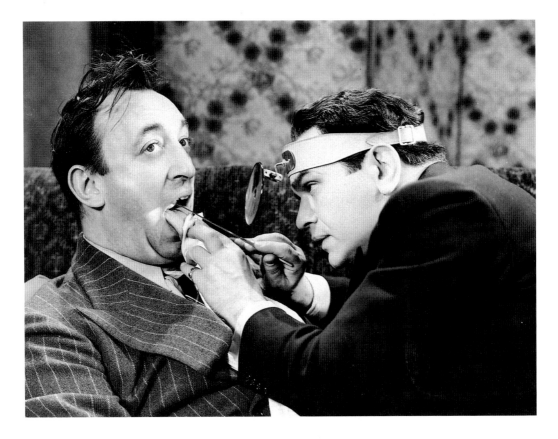

Edward G. Robinson (with Allen Jenkins)
THE AMAZING DR. CLITTERHOUSE, 1938
In films such as A Slight Case of Murder *and* Brother Orchid,
*the bull-dog-faced actor born Emmanuel Goldenberg revived his career in
the late 1930s by adeptly spoofing the gangster genre he helped create. In*
The Amazing Dr. Clitterhouse, *he plays a legit doctor determined to find out
what makes a crook tick by joining a gang led by Humphrey Bogart. Old habits
die hard, however, and quintessential Hollywood mobster Robinson eventually
succumbs to the shoot-'em-up good life by the end of this hilarious farce.*

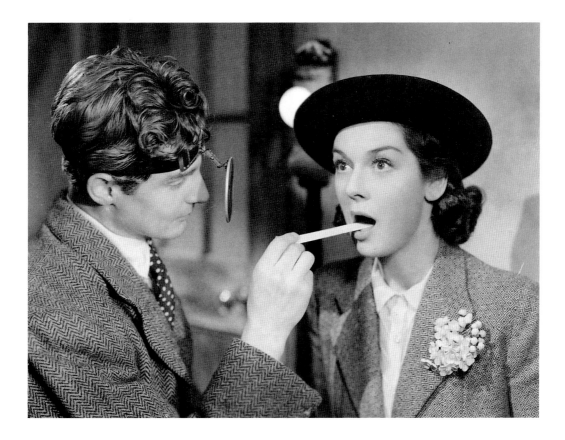

Robert Donat (with Rosalind Russell)
THE CITADEL, 1938

*A lifelong asthmatic whose illness seriously blighted his career,
the brilliant English-born actor of Polish descent was a prophetically
good choice as the dedicated doctor who battles a tuberculosis epidemic
in this Oscar-nominated offering from MGM's British studios.
Surprisingly free of the men-in-white hokum that pervades most
Hollywood doctor dramas, the picture remains one of the sincerest
portraits of the medical profession ever committed to film.*

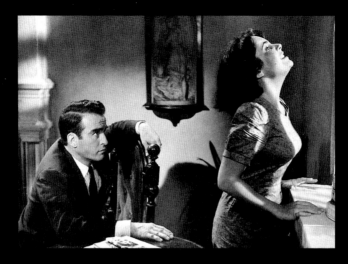

Montgomery Clift (with Elizabeth Taylor)

SUDDENLY, LAST SUMMER, 1959 (ABOVE)

*Covering forbidden topics ranging from lobotomy and homosexuality
to cannibalism and prostitution, this daring Tennessee Williams play
adapted for the screen by Gore Vidal and costarring Katharine Hepburn
gives new meaning to the term "Southern gothic." Acting as though she
had already suffered that most dreaded of brain operations, Taylor is
eventually saved from the knife by psychiatrist Clift, whose dogged
patience is tried by enough civilized depravity to fill three Williams plays.*

Ronald Colman (with Myrna Loy)

ARROWSMITH, 1931 (RIGHT)

*The first film about the medical community to deal with the
question of professional integrity versus easy money and social standing,
this popular but flawed adaptation of the Sinclair Lewis novel was
nominated for Best Picture (but lost to* Grand Hotel*). With the
exception of superb acting by Colman, Loy, and Helen Hayes and some
rather interesting trivia about bubonic plague, the picture is most note-
worthy as the forerunner of many of the formulaic, grade "B" doctor
melodramas issued by the big studios in the 1930s and 1940s.*

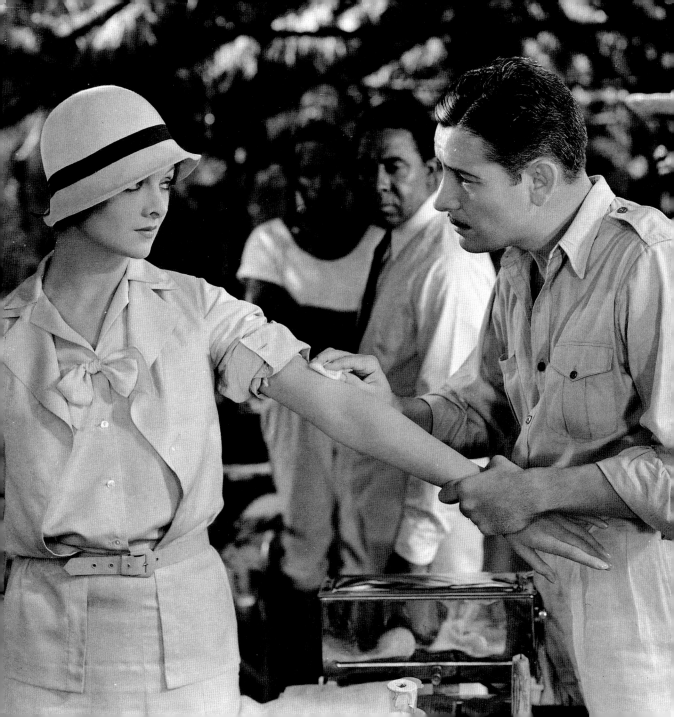

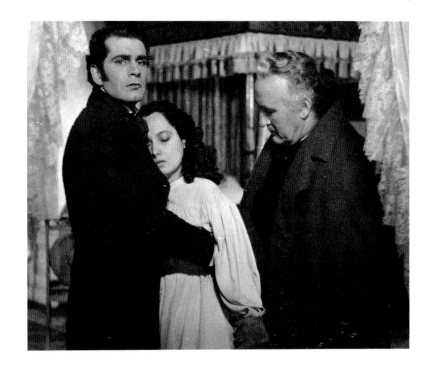

Donald Crisp (with Laurence Olivier and Merle Oberon)
WUTHERING HEIGHTS, 1939 (ABOVE)
Greta Garbo, Rex O'Malley, and Jessie Ralph
CAMILLE, 1937 (RIGHT)

*Luckily for lovers of melodrama everywhere, the talents of
kindly family doctors are no match for the grim reaper in the two
most moving death scenes ever captured on film. Both suffering from
the big screen's illness-du-jour (tuberculosis), our divinely berobed
dying swans manage one last consumptive closeup before
departing to that great big backlot in the sky.*

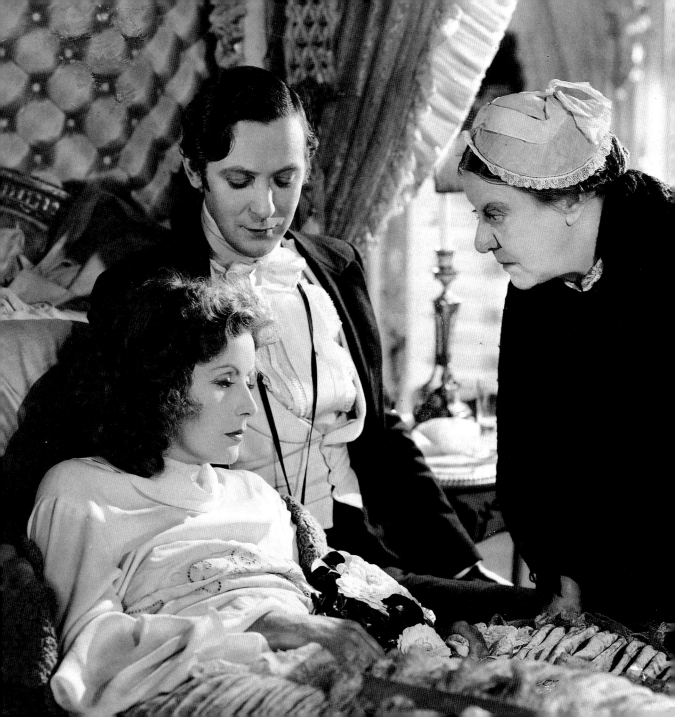

**George Brent and Henry Travers
(with Bette Davis and Geraldine Fitzgerald)**
Dark Victory, 1939

*Appearing in no fewer than eleven Warner Bros. films opposite
the feisty Miss Davis, the Irish-born Brent takes his bedside manner
from the hospital room to the heroine's bedroom in this Oscar-
nominated medical melodrama-cum-love story. Although neither
Dr. Steele (Brent) nor benign family retainer Dr. Parsons (Travers)
can do much to stave the growth of Davis's malignant brain tumor,
Brent ends up marrying the patient, doing what Hollywood's
leading lovers do best until the bitter end.*

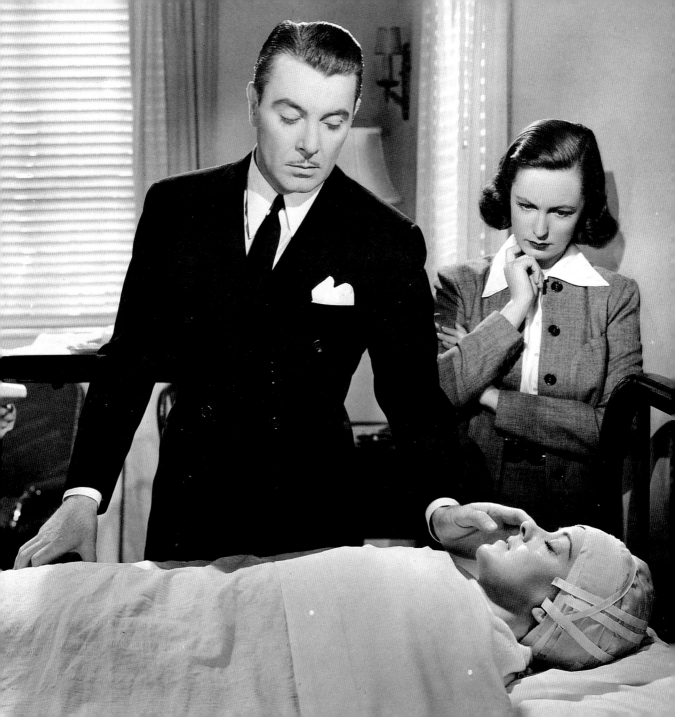

Lew Ayres, center (with Jane Wyman)
JOHNNY BELINDA, 1948
The personification of the selfless, dedicated doctor, Oscar-
nominated Ayres as Dr. Robert Richardson is the real hero of
this original and daring picture about a deaf-mute girl (Wyman)
who is raped and then gives birth to an illegitimate child.
Filmed on location on the stormy coast of northern California
(an expensive and unusual move for the time), the film resuscitated
the career of the most famous of the movie Dr. Kildares and made
Best Actress-winner Wyman (the soon-to-be ex-wife of
Ronald Reagan) an overnight star.

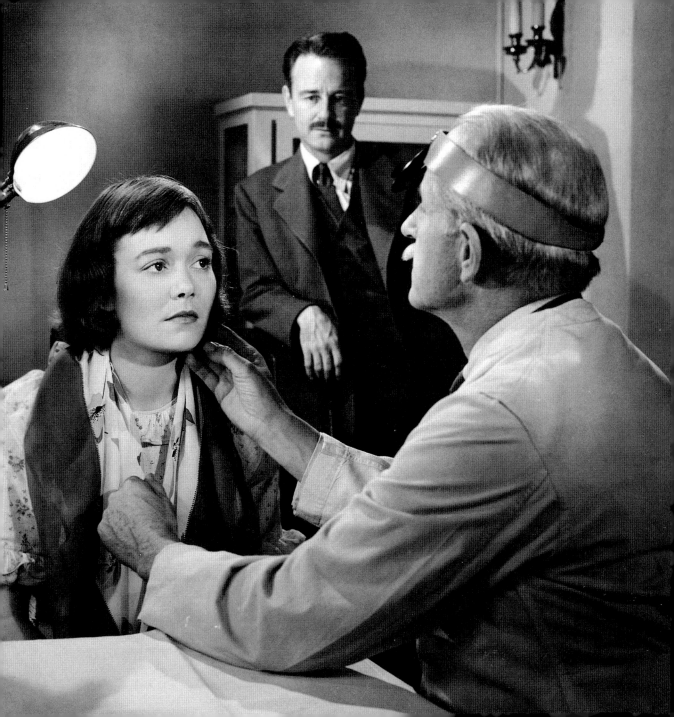

Rock Hudson (with Jane Wyman)

MAGNIFICENT OBSESSION, 1954

The movie that put Rock Hudson on the map and earned Wyman
her fourth Oscar nomination is one of Hollywood's most successful,
if preposterous, tearjerkers. When cad-about-town-turned-surgeon
Hudson, forsaking his evil ways (he accidentally killed Wyman's doctor
husband and then blinded the heroine herself), restores the actress's
eyesight by the picture's end, there is not a dry eye in the house.
Despite its absurd story line, this version of the Robert Taylor original
was one of Universal Studio's most profitable films of the 1950s.

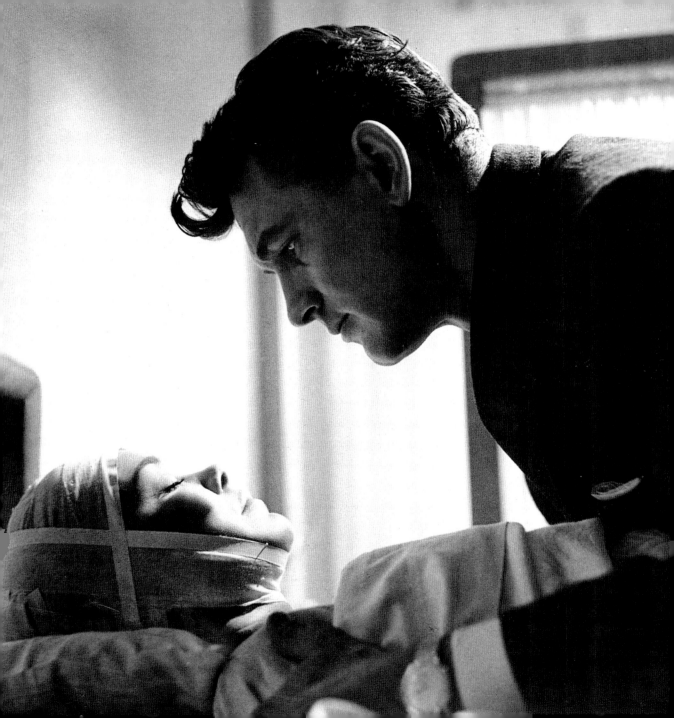

Claude Rains (with Robert Cummings)
KING'S ROW, 1942
*One of the most compelling dramas of the early 1940s
featured Ronald Reagan's finest performance outside of politics.
This decidedly dismal, unReagan-like view of small-town America
pointed up the good, the bad, and the ugly behind the curtain of
middle-class propriety—a kindly doctor (Rains) coping with a problem
child, another doctor (Charles Coburn) with a penchant for unnecessary
amputations, and a girl who "made friends on one side of the tracks and
love on the other." The film's emotional roller-coaster ride left audiences
stunned and Reagan wondering, "Where's the rest of me?"*

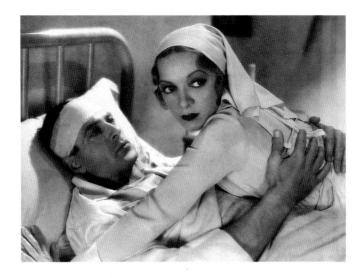

Helen Hayes (with Gary Cooper)

A FAREWELL TO ARMS, 1932 (ABOVE)

Every doctor needs a good nurse, and when the nurse's care includes more than mere medicine, it's amazing how quickly patients recover. Based on Ernest Hemingway's bittersweet real-life WWI romance with a beautiful RN named Agnes von Kurowsky, this best of all film adaptations of the author's works featured a young Cooper at his handsomest, Hayes at her most fetching, and enough pre-Hays Code hanky-panky to titillate Depression-era audiences from coast to coast.

Peter Finch (with Audrey Hepburn)

THE NUN'S STORY, 1959 (RIGHT)

The rugged, Australian-born actor and protégé of Laurence Olivier gives an inspired performance as a dedicated surgeon in the Congo who has no time for women or religion in this critically acclaimed story of a nun/nurse (Hepburn) who is torn between her divine calling and some decidedly secular feelings for the good doctor. Finch would be nominated for an Oscar twelve years later for playing yet another doctor—this time Jewish and suffering from men problems!— in the daring John Schlesinger-directed Sunday, Bloody Sunday.

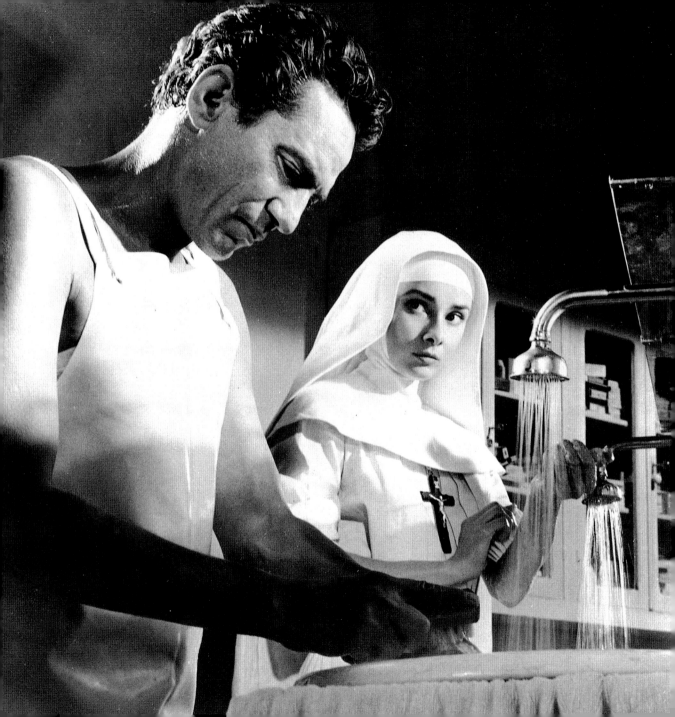

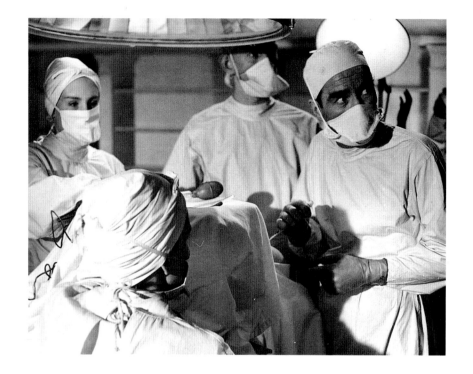

Montgomery Clift

SUDDENLY, LAST SUMMER, 1959

"Sebastian Venable died younger than most. He died abroad and alone, suddenly, last summer . . ." The problem is, Sebastian's adoring cousin (Elizabeth Taylor) knows just <u>how</u> he died (he was raped by a gang of young thugs and then eaten!) and when she reveals it, everyone thinks she is crazy. But the sensitive young Clift believes her, and he's determined to prevent Sebastian's typically batty Southern-belle mother from having her troubled niece lobotomized. Although the good doctor ultimately wins the day, this fascinating adaptation of one of Tennessee Williams's most twisted plays left a good many moviegoers feeling as if they had been lobotomized themselves.

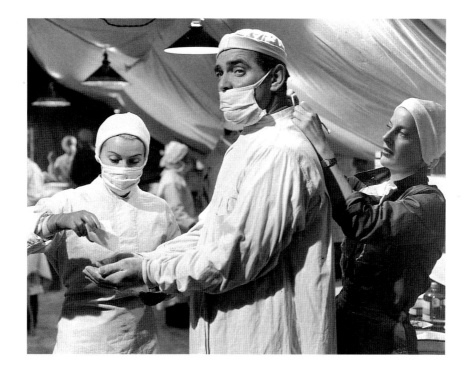

Clark Gable (with Lana Turner, left)

HOMECOMING, 1948

One of Gable's lesser efforts, this WWII MGM romance never-
theless packed in audiences gaga to see their favorite Hollywood he-
man tumble in the trenches with sweater-girl Turner. As a ruthless
society doctor called to duty by Uncle Sam, Gable smirks his way from
battlefield to bedroom and into the arms of bosomy nurse Lana.
When she is killed in action, so is the fun in this heavy-handed
wartime-romp-turned-melodrama.

Robert Taylor

MAGNIFICENT OBSESSION, 1935

*The thirty-five-dollar-a-week MGM contract player born
Spangler Arlington Brugh garnered overnight fame on a loan-out
to Universal Studios in this absurdly plotted but phenomenally
popular soaper, remade twenty years later with Rock Hudson in the
lead. The son of a country doctor, the romantically handsome Taylor
was a natural to play the playboy who becomes a surgeon to restore
the sight of the woman he accidentally blinds.*

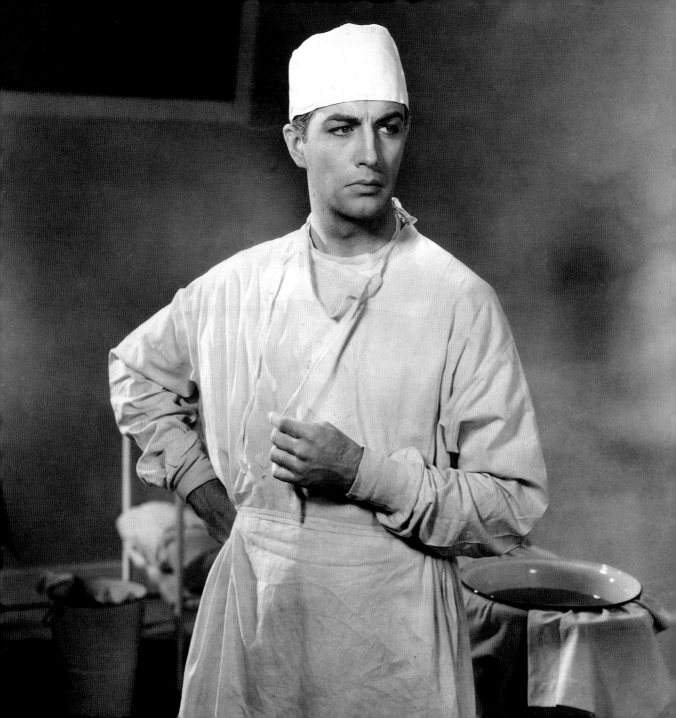

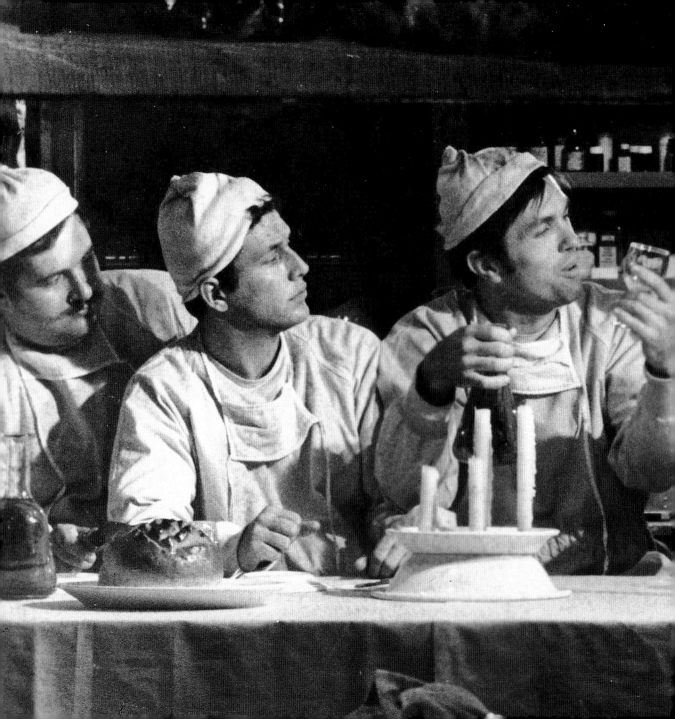

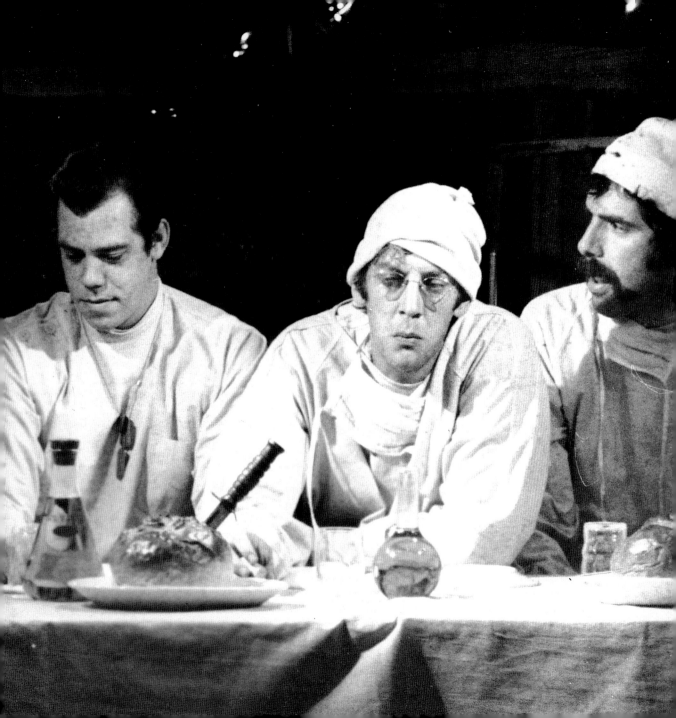

Carl Gottlieb, David Arkin, Tom Skerritt, John Schuck,
Donald Sutherland, and Elliott Gould
M*A*S*H, 1970 (PREVIOUS PAGES)

One of the most enjoyable—yet serious—war films ever made,
this "anti-everything" black comedy and predecessor of the hit television
series made a name for its director, Robert Altman, and pointed up the
humanity of doctors everywhere who must face death daily as part of
their profession. When Skerritt toasts suicidal Schuck during a mock
Last Supper, the tragi-comic absurdity of life, death, and the
pursuit of the enemy is poignantly clear.

Montgomery Clift (with David McCallum)
FREUD, 1962 (RIGHT)

Harking back to the similar Warner Bros. biopics of the 1930s
and 1940s, this film-noiresque masterpiece from director John Huston
psychoanalyzes the psychoanalyst himself. Despite (or possibly because of)
Clift's own losing battle with drug addiction, alcoholism, and depression
(as well as endless off-camera skirmishes with the director), the star
gives a taut but hypnotic performance in his penultimate
picture, the dream sequence of which is justly celebrated as
one of the eeriest in film history.

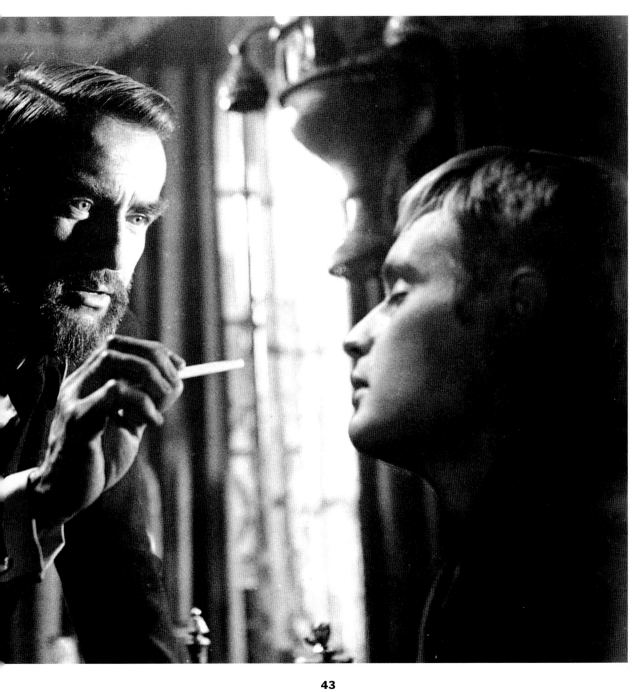

Robin Williams (with Alice Drummond)

AWAKENINGS, 1990

An overly earnest attempt by director Penny Marshall to film the true-life
story of a doctor (Oliver Sacks, played by Williams) who discovers a
temporary cure for a disease that renders its victims terminally catatonic,
this Rain Man-*style hospital epic left audiences worse off than catatonic—*
it left them bored. Williams, best when he's slightly mad himself, is
unconvincing as a gentle and retiring doctor who spends most of his time
prodding patients like Drummond to resume their old lives again.
When a few of them do, we unfortunately discover that there
wasn't much going on in their lives to begin with.

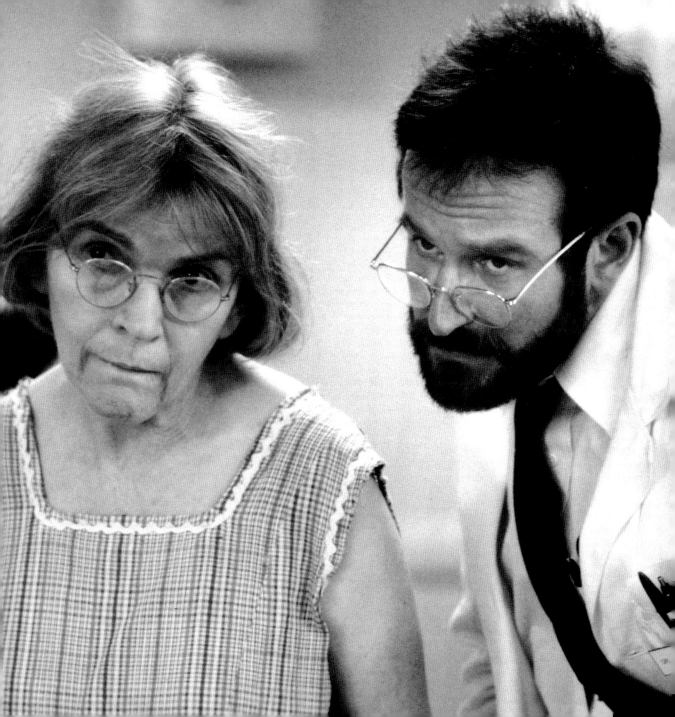

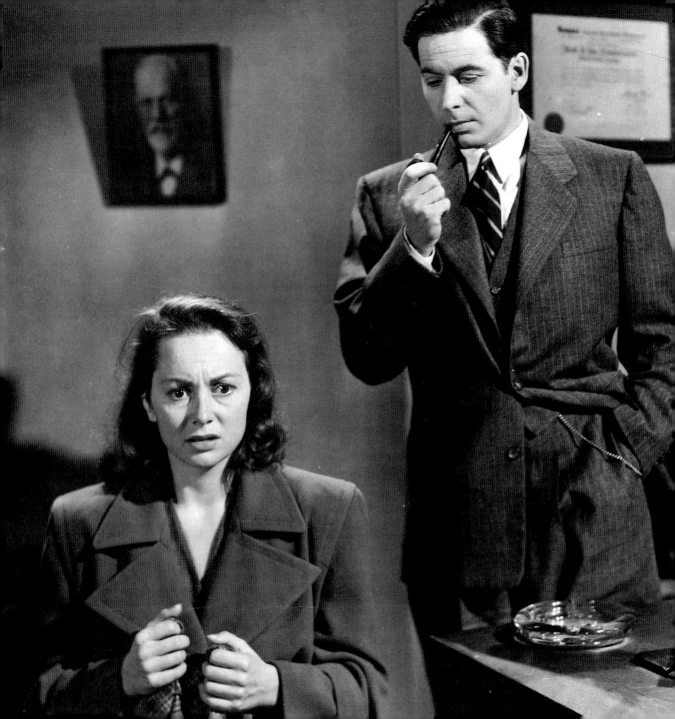

Leo Genn (with Olivia deHavilland)

THE SNAKE PIT, 1948

Although simplistic by today's Hollywood standards, the harrowing but sympathetic depiction of mental illness in this landmark film caused twenty-six states to pass groundbreaking legislation reforming their state institutions. While Genn, a distinguished real-life English barrister-turned-actor, won no awards for his performance as the earnest but overburdened head psychiatrist of an antiquated asylum, deHavilland picked up a Best Actress nomination, ultimately losing to Jane Wyman in another famous doctor drama, Johnny Belinda.

Judd Hirsch (with Timothy Hutton)
ORDINARY PEOPLE, 1980

*Hirsch's tell-it-like-it-is Jewish shrink is a welcome relief
amid the dysfunctional repression of a waspy midwestern family
that becomes unhinged after the death of their oldest child in a sailing
accident. Although this Best Picture winner brought no Oscar for the
sometime stage actor and star of the hit television series* Taxi, *
Hirsch gives a tour-de-force performance helping father (Donald
Sutherland) and youngest son (Hutton) confront super-mom-gone-
over-the-edge Mary Tyler Moore in order to face the past.*

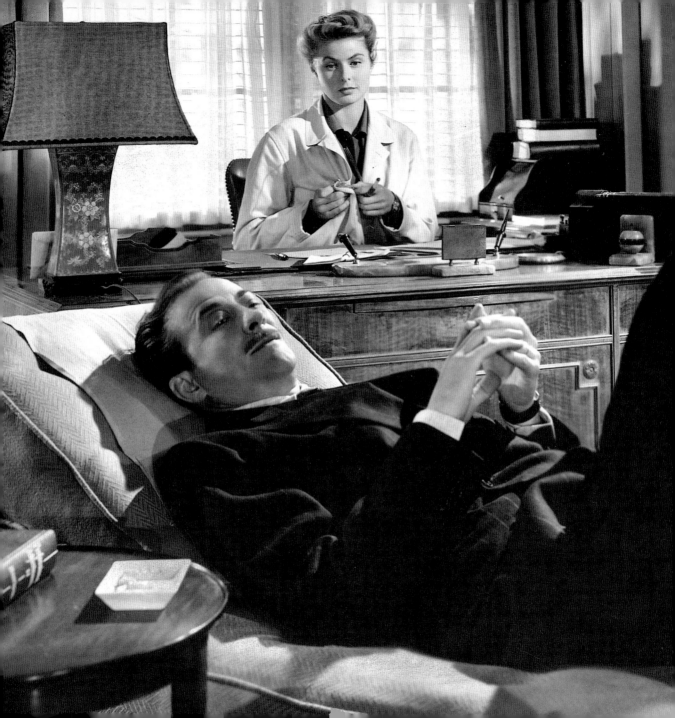

Ingrid Bergman (with Gregory Peck)

SPELLBOUND, 1945

*This fascinating picture that director Alfred Hitchcock described
as "a manhunt story wrapped up in pseudo-psychoanalysis" featured
a woman shrink (Bergman) long before Joanne Woodward* (Sybil)
and Barbra Streisand (The Prince of Tides) *made it fashionable.
A confusing tale of mistaken identity and the power of love (or modern
psychiatry, depending on your point of view), the Best Picture contender
is also noteworthy for the haunting dream sequence created by artist
Salvador Dalí. Originally running twenty-two minutes, it was too
disturbing even for Hitchcock: he retreated to London to let
another director—William Cameron Menzies—shoot it.*

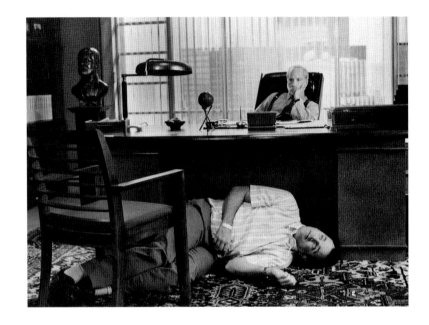

Richard Dreyfuss (with Bill Murray)
WHAT ABOUT BOB?, 1991 (ABOVE)
Barbra Streisand
THE PRINCE OF TIDES, 1991 (RIGHT)

*Psychiatry turned sinister and romantic all in the same year with two
films that said as much about the instability of psychiatrists as they did the
instability of the patients themselves. Dreyfuss, the very picture of the collected
professional, eventually becomes as crazy as his obsessive client, while Streisand,
all manicured nails and New York mannerisms, has an affair with hers.
Perfect fodder for any tabloid-TV talk show, the plots of both pictures turned
the field of psychiatry on its collective ear (intentionally in* What About Bob?,
unintentionally in The Prince of Tides) *and made us long for
the days when the shrinks were the sane ones.*

Gary Cooper

THE STORY OF DR. WASSELL, 1944

The real-life WWII story of Commander Corydon M. Wassell,
a military doctor decorated by Franklin Roosevelt for his bravery,
this Cecil B. deMille epic was an unmemorable effort by Cooper, who
had won his first Oscar two years previously playing another kind of
military hero in Sergeant York. *Called by one critic "a cacaphony of*
dancing girls, self-sacrifice, and melodramatic romance," this long-winded
saga featured a few scenes that did manage to convey some of the
harrowing M*A*S*H-*like reality of the wartime field hospital.*

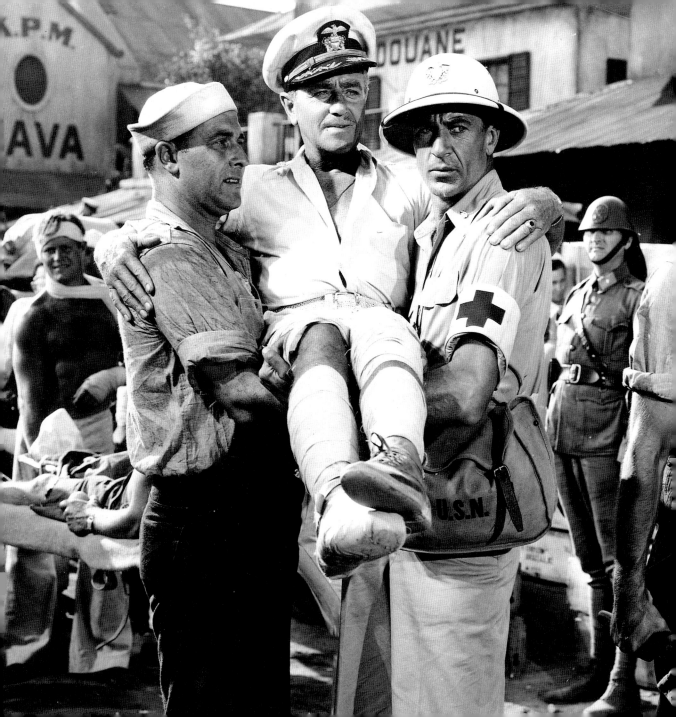

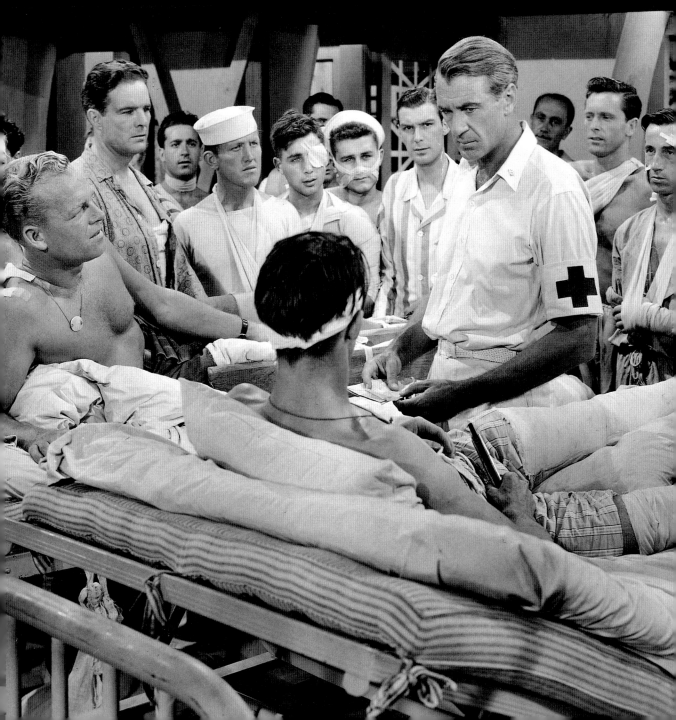

Gary Cooper

THE STORY OF DR. WASSELL, 1944

In one of the few poignant scenes in this largely glamorized account
of a real-life doctor's derring-do in the Pacific Theater during WWII,
Dr. Wassell (Cooper) informs his patients that they will be left behind
as Allied forces retreat in the face of an imminent Japanese invasion.
Bucking authority (and the odds), Wassell eventually gets the men
out single-handedly, earning a few medals in the process and
a place forever in the good-doctor hall of fame.

Harry Davenport (with Vivien Leigh and
George Hackathorne, bottom)
GONE WITH THE WIND, 1939
One of Hollywood's most beloved character actors,
the seventy-three-year-old scion of a long line of show-business
personalities made one of the cruelest cuts in film history (the amputa-
tion in King's Row *gets first prize) in this memorable and particularly*
chilling scene from America's most time-honored celluloid saga.
Responsible for thousands of wounded and dying Confederate soldiers,
the kindly but overtaxed doctor is a poignant metaphor for the despair
and enfeeblement of the entire Southern army by the war's end.

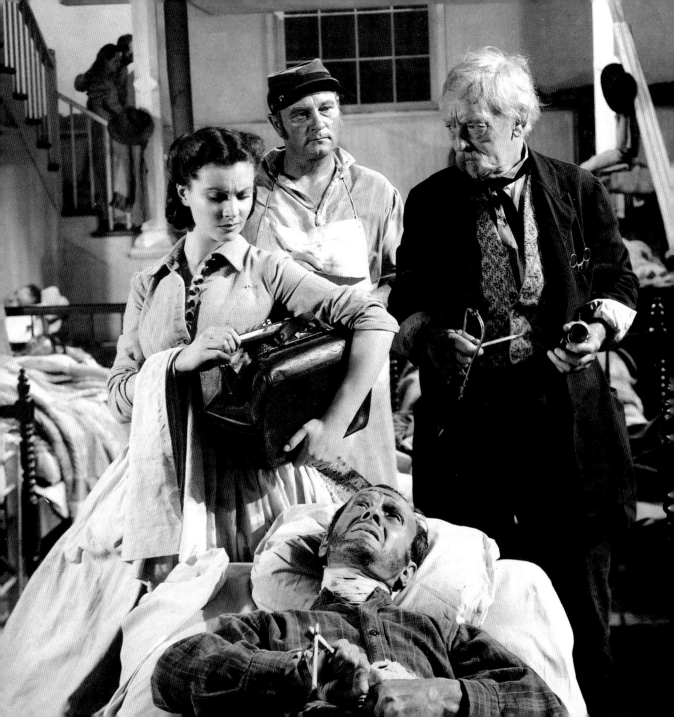

Omar Sharif

DOCTOR ZHIVAGO, 1965

*Dedicated scientist and doctor, esteemed poet, world-class lover
(and gifted balalaika player to boot), the dreamy-eyed Russian
protagonist played by the handsome Egyptian-born screen lover is
almost too good to be true. Unfortunately for the star of this Russian
Revolution romance (with a bit of medical melodrama thrown in
for good measure), Zhivago is also a man of principle, and his
anti-Communist intractability ultimately spells his doom.*

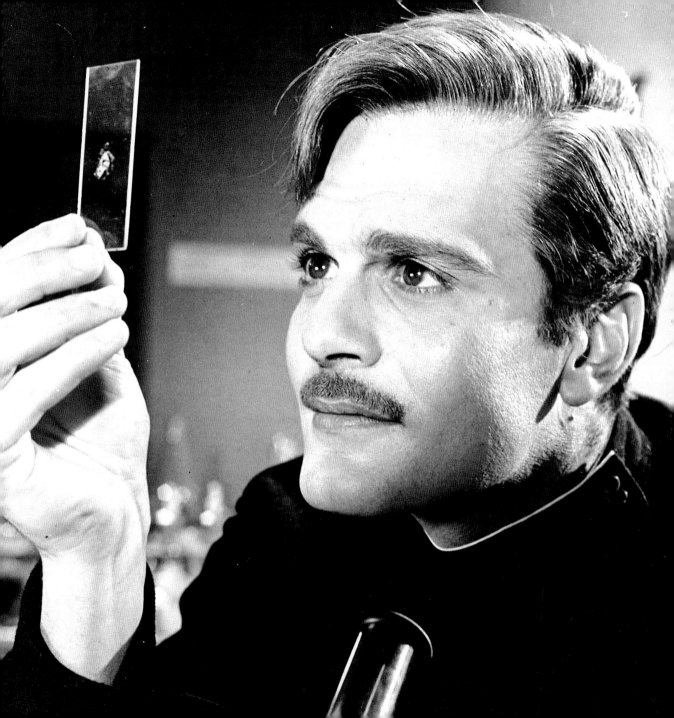

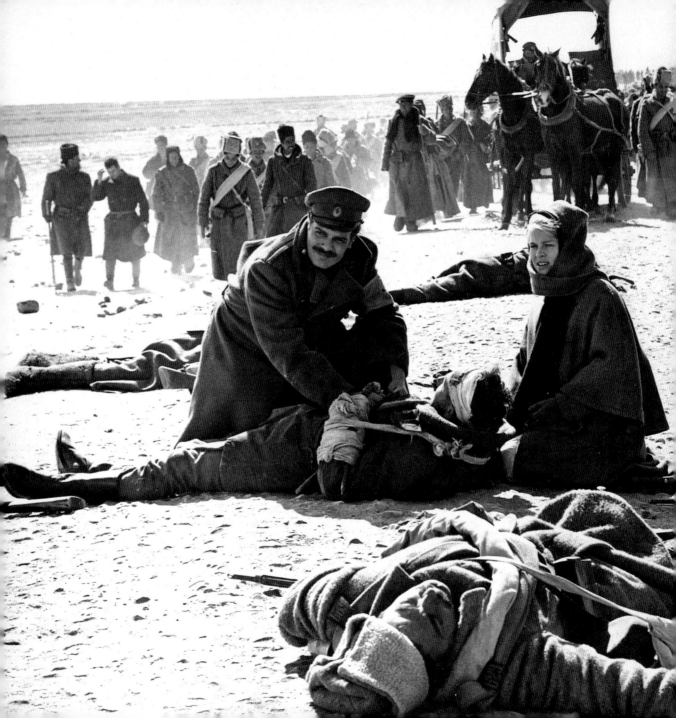

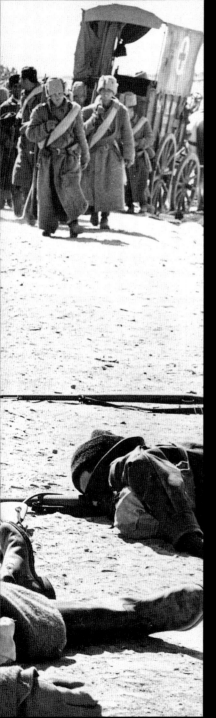

Omar Sharif (with Julie Christie)

DOCTOR ZHIVAGO, 1965

*In one of the more brutal scenes in this stunningly photographed
wartime epic, the do-gooder Dr. Zhivago and Nurse Antipova
(his love-mate-to-be) tend to wounded Tsarist soldiers who have been
viciously massacred by a brigand of WWI deserters. A doctor who
takes his Hippocratic oath seriously, he is eventually forced to
hide out in Siberia after being charged with conspiring
with the anti-revolutionary Whites.*

Paul Muni

THE STORY OF LOUIS PASTEUR, 1936

*A method actor ahead of his time, Warner Bros.' powerhouse star
changed his voice and appearance so often in his on-screen roles that
he was virtually unrecognizable from one film to the next. Having just
played a doctor who gets mixed up with a pack of gangsters in* Dr. Socrates,
*Muni won a Best Actor Oscar for his 360-degree transformation into the
saintly Dr. Pasteur. One of Hollywood's most impressive screen biographies,
the surprise hit led to Muni's critically acclaimed roles in two other
Warner biopics—*The Life of Emile Zola *and* Juarez.

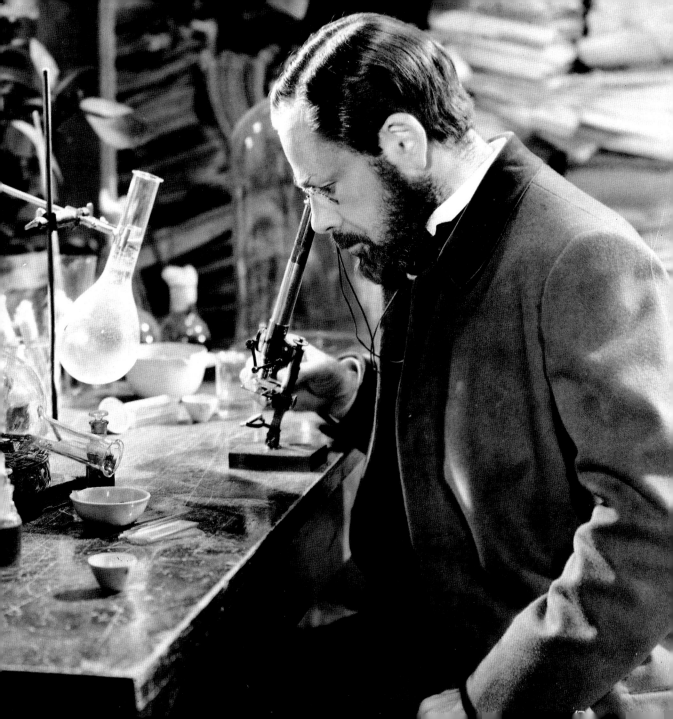

Edward G. Robinson

DR. EHRLICH'S MAGIC BULLET, 1940

*One of the best entries in the superb series of historical biopics
from Warner Bros., this surprisingly compelling docudrama featured
everyone's favorite gangster in a remarkable change of role—as the
gentle and dedicated Dr. Paul Ehrlich, the German research scientist who
discovered the cure for venereal disease. Hardly standard Hollywood fare,
the film capitalized on John Huston's superb writing, William Dieterle's
sensitive direction, and Robinson's electric performance and broke
all the rules when it won both critical and popular acclaim.*

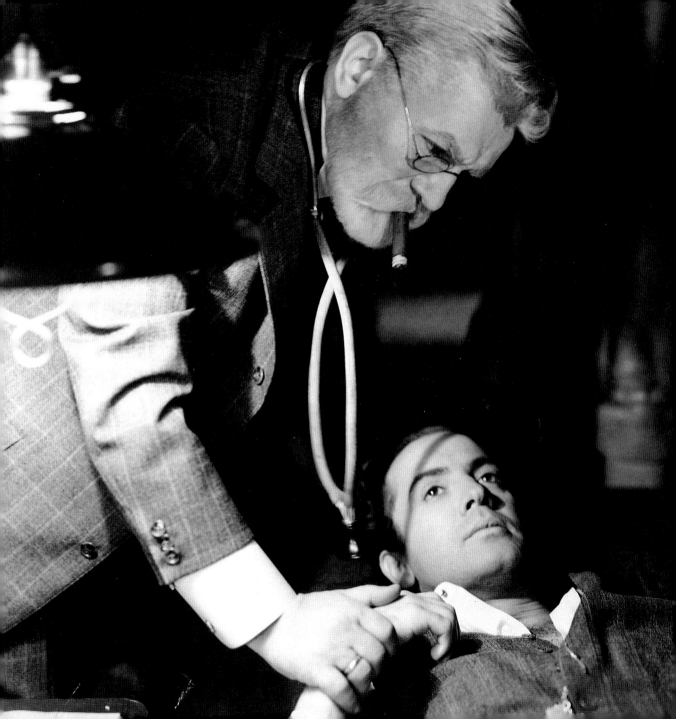

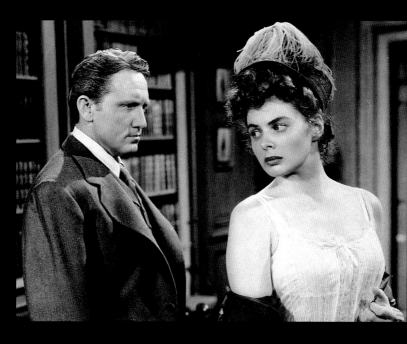

Spencer Tracy (with Ingrid Bergman)
DR. JEKYLL AND MR. HYDE, 1941 (ABOVE)
Fredric March
DR. JEKYLL AND MR. HYDE, 1931 (RIGHT)
*The classic Robert Louis Stevenson story of the Victorian doctor
who finds a formula that separates the good and evil in his soul brought
accolades and an Oscar to March but only tepid reviews for Tracy's later
version. Originally filmed in 1921 with John Barrymore in the lead
(his transformation into Mr. Hyde was accomplished through facial
contortions rather than makeup!), the trials of Hollywood's most lucrative
mad doctor were later successfully spoofed in no fewer than twelve spin-offs
ranging from horror to outright comedy, including* Abbott and Costello
Meet Dr. Jekyll and Mr. Hyde *and* Dr. Jekyll and Sister Hyde.

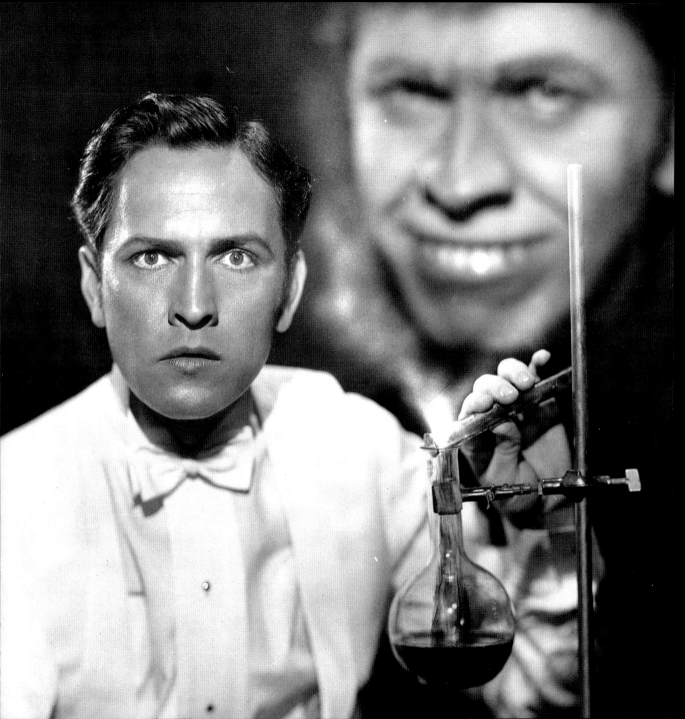

Paul Muni

DR. SOCRATES, 1935

Fresh from his success in Scarface *and* I Am a Fugitive
from a Chain Gang, *Warner Bros.' favorite gangster and
most accomplished thespian switched gears to play the good guy, as a
small-town physician who unwillingly becomes the doctor of choice for
wounded mobsters. The film allowed Muni to gracefully break out of
his gangster typecasting; he went on to win an Oscar his next time out
playing another, more famous doctor in the most successful of the
celebrated Warner Bros. biopics,* The Story of Louis Pasteur.

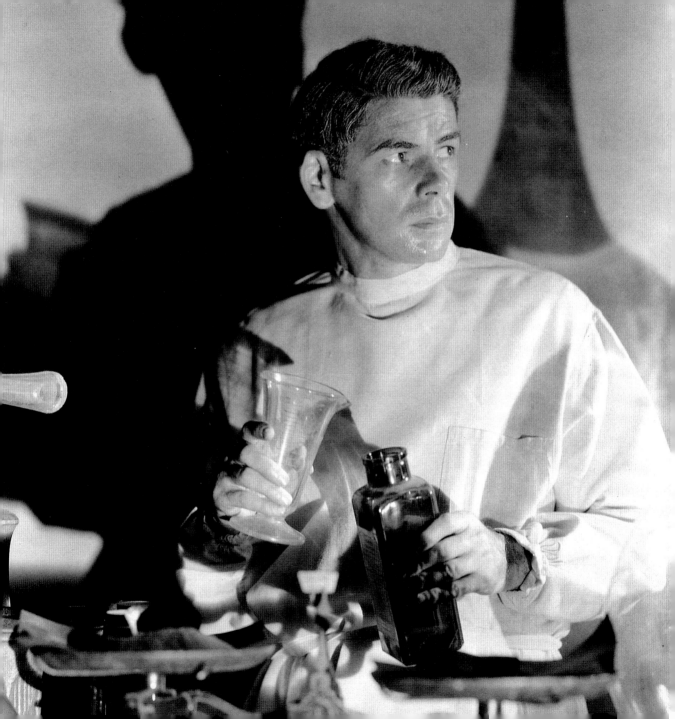

John Litel (with Humphrey Bogart)

THE RETURN OF DR. X, 1939

*A talented, dependable character actor (he appeared in over
200 films), Litel played a variation of the infamous Dr. Frankenstein
in this Vincent Sherman-directed grade-"B" Warner Bros. shocker
based on the popular horror story,* The Doctor's Secret, *by William J.
Makin. In no way a sequel to the 1932 hit* Dr. X *(although it profited
from the presumed connection), the picture is mostly interesting for
Bogart's bizarre turn as the doctor's pale-faced-zombie creation
with a vampiric predilection for human blood.*

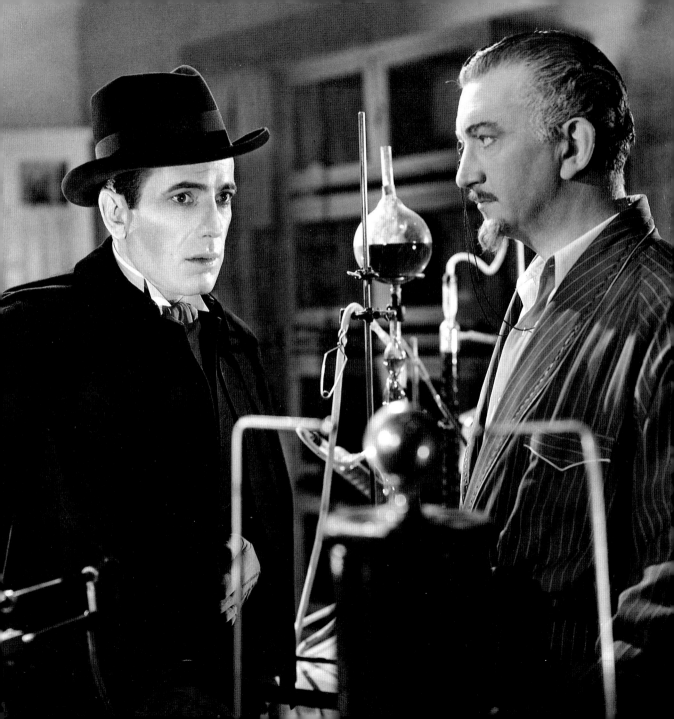

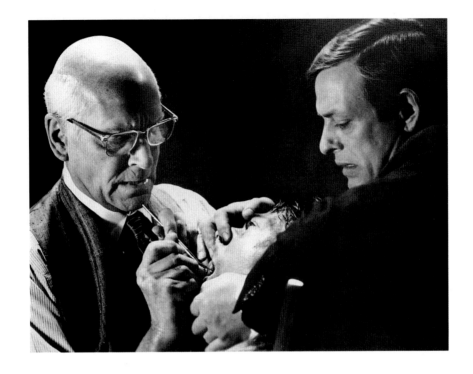

Sir Laurence Olivier
(with Dustin Hoffman and Richard Bright)
MARATHON MAN, 1976 (ABOVE)
Gregory Peck
THE BOYS FROM BRAZIL, 1978 (RIGHT)

Doctors from Hell, Olivier and Peck gave the German medical
establishment a bad name in these two Jewish-revenge-fantasy thrillers
that both garnered Best Actor nominations for Olivier (he was the good
guy in The Boys from Brazil*). Although Peck's gene-cloning psycho*
genius (Dr. Josef Mengele) is appropriately sinister, Olivier's sadistic
Nazi-dentist-with-a-killer-drill is a consummate, if unsettling,
portrayal of evil by the greatest English-speaking (even
with a German accent) actor in the world.

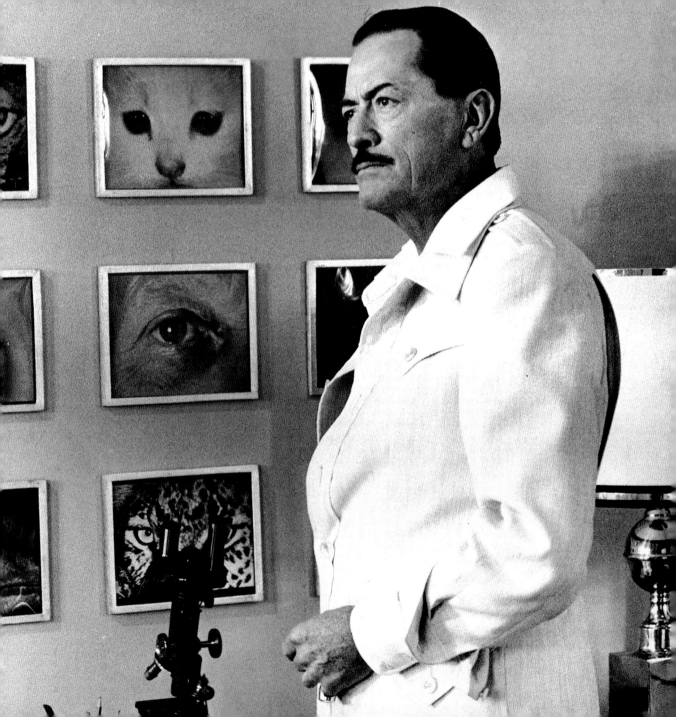

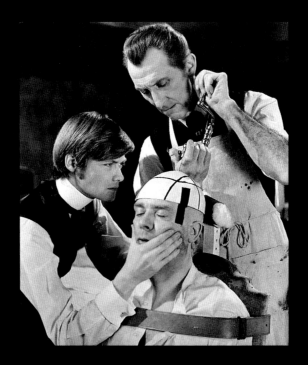

Peter Cushing (with Simon Ward and Freddie Jones)
FRANKENSTEIN MUST BE DESTROYED, 1969 (ABOVE)
Colin Clive (with Dwight Frye and Boris Karloff)
FRANKENSTEIN, 1931 (RIGHT)

*Moviedom's most celebrated monster-making mad doctor has
been reincarnated in dozens of films with varying degrees of success.
Even Clive's memorable psycho scientist in the 1931 smash "original"
was not really the first; a rarely seen 1908 version holds that honor.
Of all the Dr. Frankensteins to wreak havoc on the big screen,
certainly none was more fiendish than Cushing in six of the seven
blood-soaked, low-budget, big-box-office entries from Britain's
Hammer Films. In the sixth installment of that series, the now-old
and embittered doctor successfully transplants the brain
from one colleague into another . . . well, almost.*

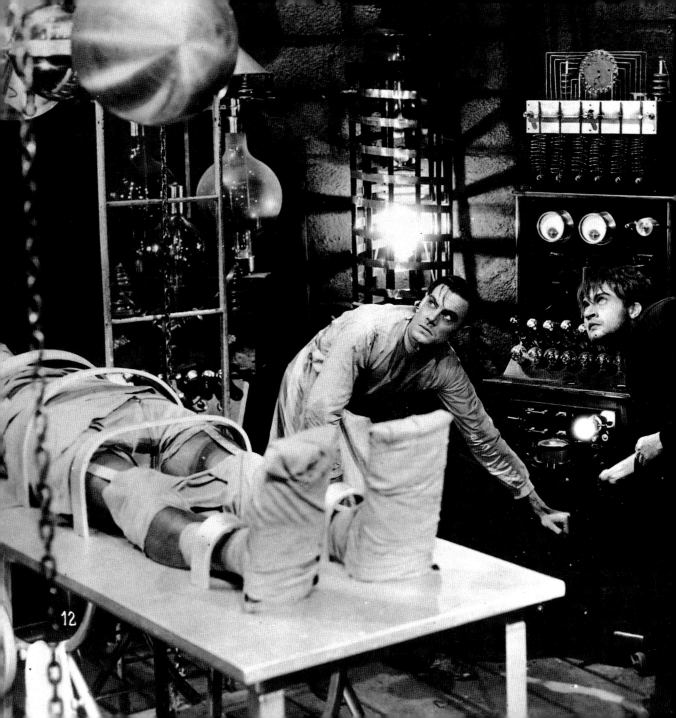

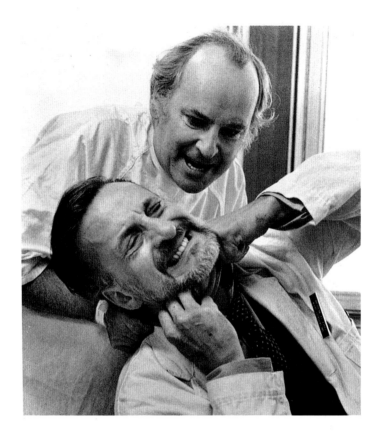

George C. Scott (with Barnard Hughes)
THE HOSPITAL, 1971

What playwright and screenwriter Paddy Chayevski's Network
*did for television, his Oscar-winning script did for the medical establish-
ment in this blackly comical and ultimately depressing story of a surgeon
(Scott) who battles the unpleasant goings-on (including murder) in his
own big-city hospital. A* M*A*S*H-*like mixture of Marx Brothers
slapstick and uncompromising satire, the film made audiences—
and the AMA—laugh and cry at the same time.*

Project Editor: J. C. Suarès
Text: J. Spencer Beck
Picture Editor: Leslie Fratkin

Front Cover: *Culver Pictures*
Back Cover: *Lester Glassner Collection/*
Neal Peters
3: *Courtesy The Kobal Collection*
7: *Culver Pictures*
8: *Photofest*
9: *Photofest*
11: *Culver Pictures*
12: *Neal Peters Collection*
13: *Photofest*
14: *Culver Pictures*
15: *Photofest*
16: *Photofest*
17: *Photofest*
18: *Culver Pictures*
19: *Culver Pictures*
20: *Photofest*
21: *Photofest*
22: *Courtesy The Kobal Collection*
23: *Photofest*
24: *Photofest*
25: *Courtesy The Kobal Collection*
26-27: *Courtesy The Kobal Collection*
29: *Photofest*
31: *Courtesy The Kobal Collection*
32-33: *Photofest*
34: *Photofest*
35: *Photofest*

36: *Courtesy The Kobal Collection*
37: *Courtesy The Kobal Collection*
39: *Culver Pictures*
40-41: *Photofest*
42-43: *Courtesy The Kobal Collection*
45: *Everett Collection*
46: *Photofest*
48-49: *Photofest*
50-51: *Photofest*
52: *Photofest*
53: *Photofest*
55: *Photofest*
56: *Everett Collection*
59: *Photofest*
61: *Courtesy The Kobal Collection*
62-63: *Neal Peters Collection*
65: *Everett Collection*
67: *Photofest*
68: *Photofest*
69: *Photofest*
71: *Photofest*
73: *Culver Pictures*
74: *Courtesy The Kobal Collection*
75: *Photofest*
76: *Photofest*
77: *Courtesy The Kobal Collection*
78: *Photofest*